**ALLIANCE FOR THE ARTS
IN RESEARCH UNIVERSITIES**

Copyright © 2020 by the Regents of the University of Michigan

Some rights reserved

This work is licensed under the Creative Commons Attribution-ShareAlike 4.0 International License.

To view a copy of this license, visit http://creativecommons.org/licenses/by-sa/4.0/ or send a letter to Creative Commons, PO Box 1866, Mountain View, California, 94042, USA.

Published in the United States of America by
Michigan Publishing

DOI: https://doi.org/10.3998/mpub.11726264

ISBN 978-1-60785-665-8 (paper)
ISBN 978-1-60785-666-5 (open-access)

A2RU PARTNER UNIVERSITIES

Boston University
Dartmouth College
James Madison University
Johns Hopkins University
Kent State University
Louisiana State University
Massachusetts Institute of Technology
Michigan State University
Northeastern University
Oregon State University
Penn State
Pontificia Universidad Católica de Chile
Princeton University
Rochester Institute of Technology
Texas Tech University
Tufts University
The University of Alabama
The University of Alabama at Birmingham
University of Arkansas

University of Cincinnati
University of Colorado Boulder
University of Florida
University of Georgia
University of Houston
University of Illinois at Urbana-Champaign
University of Iowa
University of Kansas
University of Maryland
University of Michigan
University of Nebraska-Lincoln
University of Nevada, Las Vegas
University of North Texas
University of Texas at Dallas
University of Utah
University of Virginia
University of Wisconsin-Madison
Virginia Commonwealth University
Virginia Tech

The Alliance for the Arts in Research Universities (a2ru) is a partnership of over 40 institutions committed to ensuring the greatest possible institutional support for the full spectrum of arts and arts-integrative research, curricula, programs, and creative practice for the benefit of all students and faculty at research universities and the communities they serve.

"In study after study, arts participation and arts education have been associated with improved cognitive, social, and behavioral outcomes in individuals across the lifespan."

("Arts and Human Development" 2011, 7).

IMPACTS OF ARTS INTEGRATION & INTERDISCIPLINARY PRACTICE

A2RU Research to Practice

Where the arts have a lively presence on campus, and interact with other disciplines as well as across the boundaries of the university, we find a range of impacts. Some of them are high-level—recurring and broadly applicable—while others are specific to a particular group or field. This report presents a synthesis of our research findings on the impacts of the arts and interdisciplinary practice on student experiences in and out of the classroom. Companion reports recount the impacts we found in other areas and for other populations.

Our taxonomy of impacts is built on examples that surfaced from interview and survey data, and on a review of the literature. Some impacts are verified with experimental studies and some are anecdotal or aspirational; thus, we consider this a taxonomy of the potential impacts of arts integration in the university. Two extensive studies form the basis of our research. In the SPARC (Supporting Practice in the Arts, Research, and Curricula) interviews with academic leadership, faculty, and students at 38 universities, we asked about the impact of their arts-integration initiatives, including teaching, research, and community projects. In addition, a four-year survey-based longitudinal study explored ~4000 undergraduates' arts engagement at the University of Michigan. For more information about our research process, see pages 30-32; you can find notes on how the different types of sources are cited on page 28.

In addition to reports like this one, our insights into the impacts data are available as a graphic map (the images on the cover and on page 5 are excerpted from it). Each type of resource has a distinctive function. Readers can use the map for a broad overview of the impacts taxonomy, browsing for categories of impact that interest them; alternatively, the reports go deeper into the research, discussing some impacts in detail and providing specific examples of many types of impact. The map and reports are meant to ignite discussion, fuel research, and support clear communication. We encourage users to appropriate the taxonomy for advocacy and case-making, as a locator guide to identify where impacts can occur, and as a shared reference point and vocabulary for pursuing arts-integrative initiatives in the university. However, it is most exciting as a jumping-off point to further exploration.

https://www.a2ru.org/impacts/

A Jumping-off Point for Exploration

In our analysis of arts integration in the university, we organized categories of impact into a structure wherein the categories have relationships to each other. While that structure is more cyclical than linear, in narrating it here, we need an entry point—a beginning for the story. Our account of the impacts begins then with the convergence of two forces, or concepts: the arts and interdisciplinarity. These are the component parts of arts integration.

Several broad categories of impact that are pervasive and recurring—including *New Perspective, Awareness, and Understanding* and *Working Together*—emerge directly out of this arts-integrative situation. We also identified impacts on specific areas such as *Teaching, Research,* individual *Disciplines,* and of course, *Students*.

The impact of the arts and interdisciplinarity on students is tremendous. Not only are there the direct impacts on their learning and socio-cultural experience, there are also lingering impacts on their futures. Furthermore, students move through all the areas of academia, experiencing arts integration's impacts there indirectly. Because impacts on students are so many and varied, we present them in two separate reports.

This report unpacks far-reaching impacts on students' personal and social experiences—on not only their own growth and development but also their connections to others. It also explores impacts on student learning, and practical impacts that prepare them for the professional world they encounter beyond the classroom. Finally, it briefly touches on some of the ways that experiences with the arts impact students' lives after graduation.

A separate report details the long list of skills and capacities that students build through their experiences with the arts. Additional reports explore other impacts of arts integration, both broad and specific.

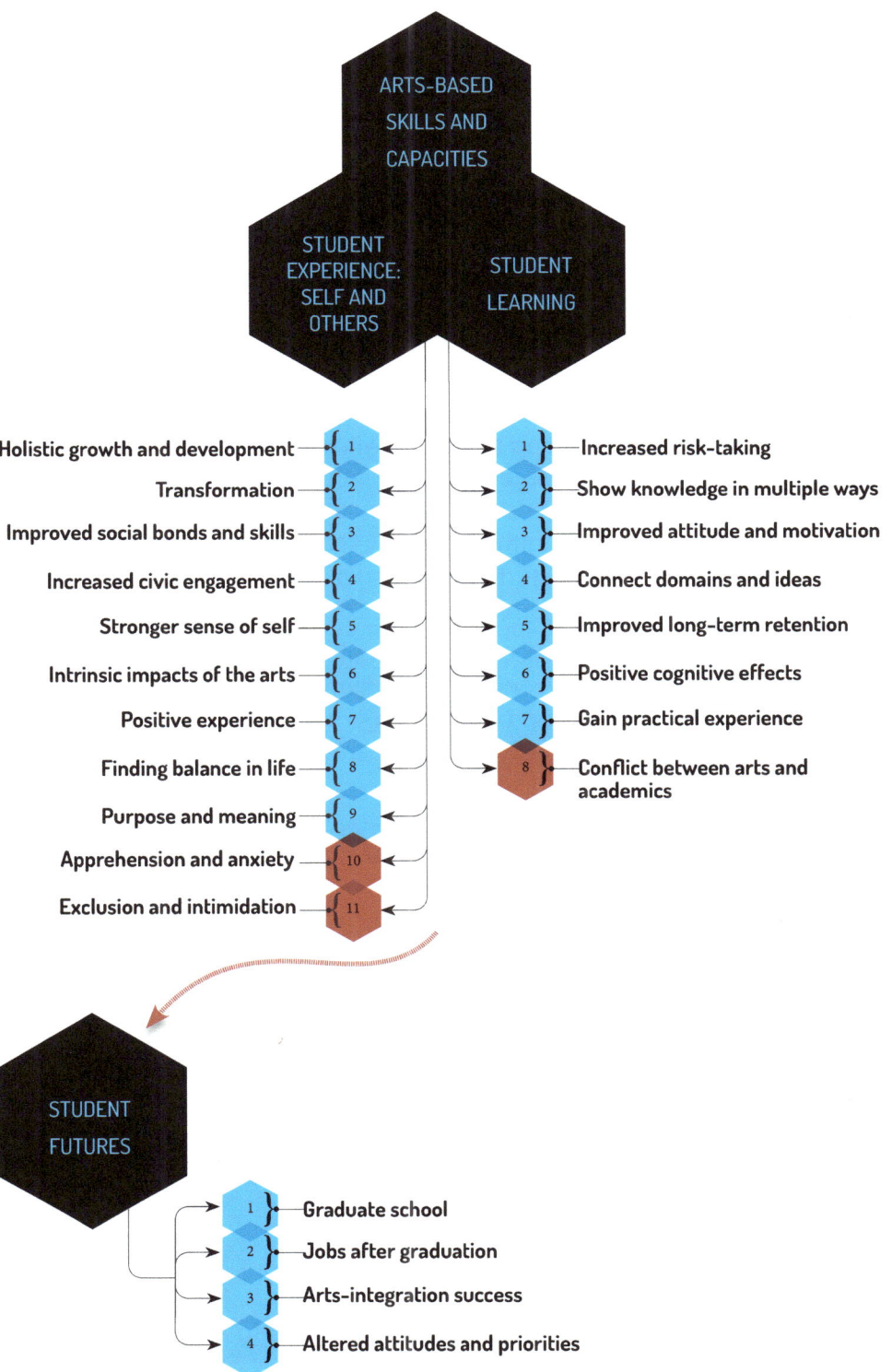

Exploring Student Experiences with the Arts

More than any other area of our analysis, this section on student experiences represents a mix of impacts found in the SPARC data, in the U-M longitudinal study, and in the literature.

Impacts in the category "Student Experience: Self and Others" are grounded in many examples from interviews with and surveys of faculty and students, with occasional support from the literature. Students and instructors alike recount how the arts promote personal growth, distinct from academic growth. It is in this category that the first-person accounts from U-M students are most powerful.

By contrast, we have very few examples of students talking about the arts in the context of learning in the classroom, and faculty respondents spoke about only a few impacts on student learning. However, there are many documented classroom impacts that we consider too important to neglect; these we have assembled from the literature in the category "Student Learning."

Finally, our category "Student Futures" is comprised entirely of SPARC interview responses. Although there is a growing body of research that explores the impacts of college arts experiences on students post-graduation, incorporating it here was beyond the scope of this project.

These impacts on students' lived experiences in and out of the classroom indicate some of the potential power of an arts-integrated campus.

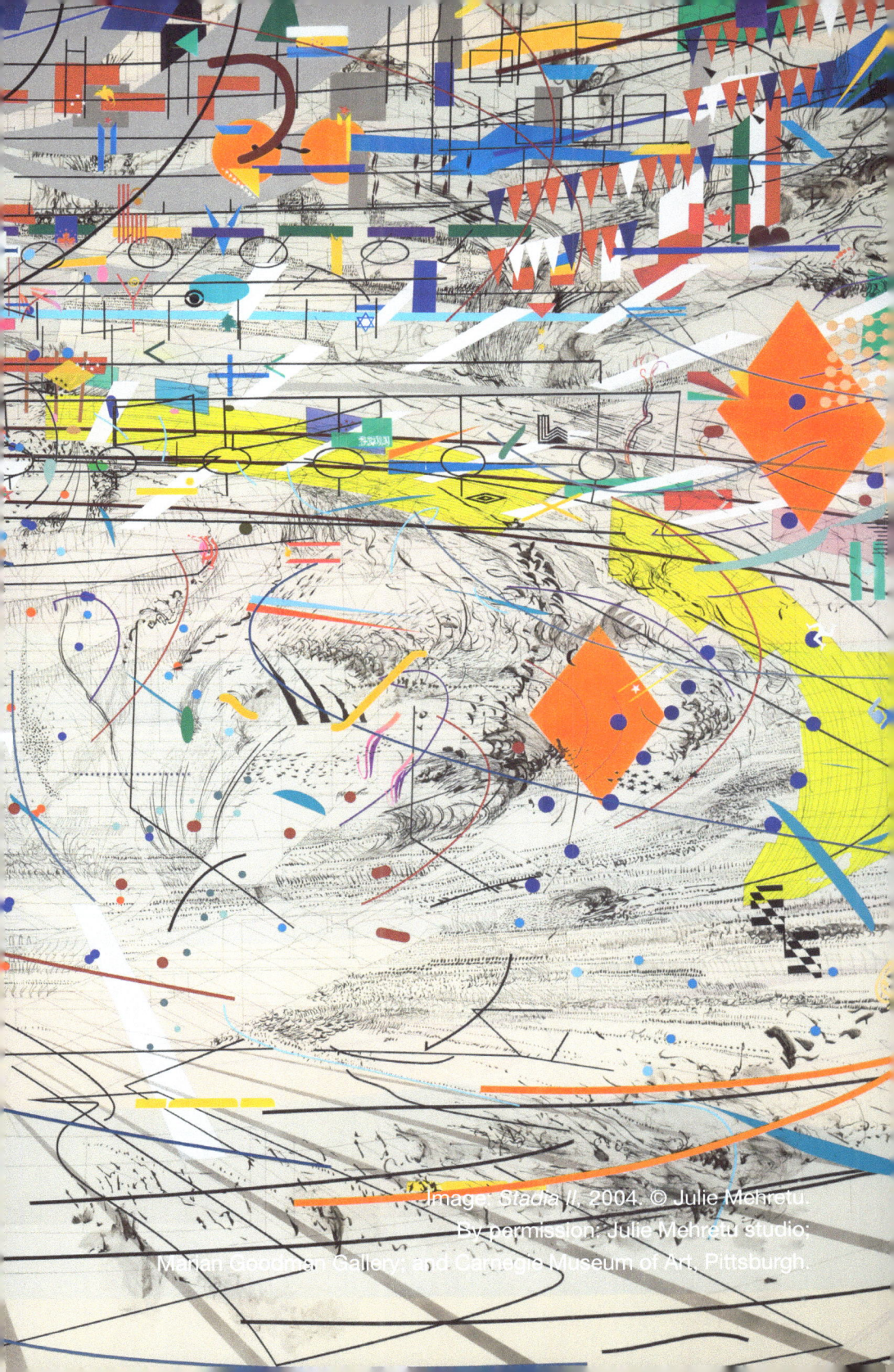

Image: *Stadia II*, 2004. © Julie Mehretu. By permission: Julie Mehretu studio; Marian Goodman Gallery; and Carnegie Museum of Art, Pittsburgh.

STUDENT EXPERIENCE: SELF AND OTHERS

In addition to general growth and development, "transformation" emerges as its own category of impact on students. In instances of transformation, students' fundamental beliefs, behaviors, and goals change because of encounters with the arts. For some students, the arts inspire a stronger sense of self, or impart meaning and purpose to life. Many students report simply that the arts give them enjoyment and happiness. In addition to these inward-facing impacts, students create new social bonds and increase their social skills through the arts. Some are inspired to increase their civic engagement. The net result for some students is an increased sense of balance in their lives.

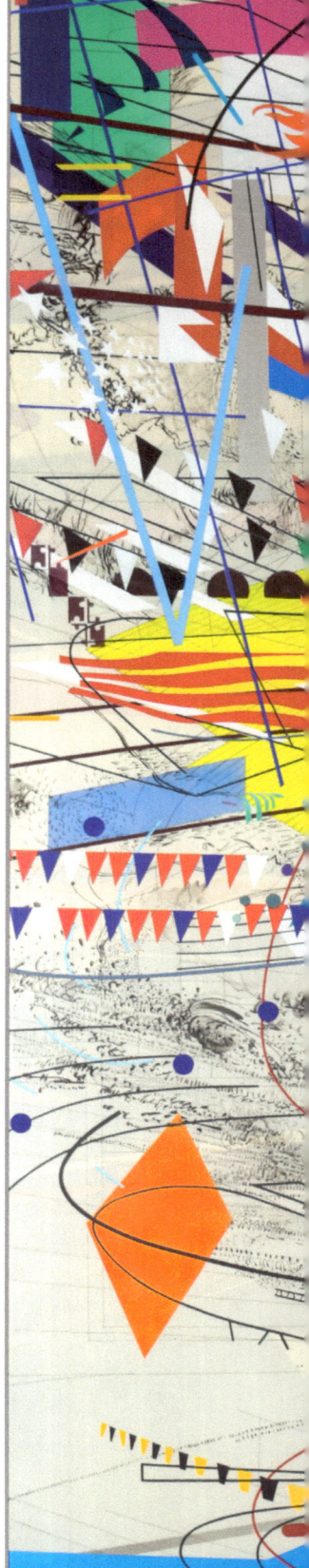

HOLISTIC GROWTH AND DEVELOPMENT

"It was really more about this kind of growth, their [students'] own personal growth and their own understanding of what it means to be involved in a community and what it means to have the kind of experience that they've had in a program that just helped to think beyond the art itself." (Q25-3103-6159)

"A number of them [students] that we spoke to said they have their eyes open to other possibilities for their music, and they went, 'I could do this.' This was really exciting for them and a unique experience." (Q25-2309-5957)

One undergraduate's response to a question about how the arts have helped you grow: "Spiritually, emotionally, mentally, physically, tentatively, financially, qualitatively, quantitatively, happily, paradoxically, sexually, thoughtfully, and creatively." (UM-AE: In what ways do you think you can grow through the arts?)

IMPROVED SOCIAL BONDS AND SOCIAL SKILLS

"It makes me feel connected with the rest of the student body. I may not be able to personally work in some of the events that I attend, but I am able to understand and appreciate the amount of work and dedication that was put in by those who I observe. I'm able to get an impression of the rest of my fellow students and of their work." (UM-AE: How did your involvement in the arts during college make you feel?)

"Certain arts activities promote growth in positive social skills, including self-confidence, self-control, conflict resolution, collaboration, empathy and social tolerance." (Ruppert 2006, 14)

TRANSFORMATION

"...students could write about their experiences and how it changed them. We got good evidence that, they all called it a life-changing experience." (Q25-2820-3442)

"We definitely saw that. I called it the forked path; that was one of the highest metrics for that [arts-integrated] course, was how many forked paths did we make. If someone was on the same trajectory in terms of where it would end up in employment, or where it would end up in grad school, and then after the experience of being in the course, they went somewhere else. To me, that shows that through reflection, or experience, or just exposure, we were actually having an experience which changed the way that [students] saw what it was they wanted to do in the future." (Q25-1804-6299)

"[A student] said, 'Well, I didn't really want to be in this class but I thought it's something that I should do.' And he completely realigned his perspective from the start of the semester...and he came back for the second semester and he developed [a thesis on the topic] through the investigations across the discipline." (Q25-3701-8233)

STRONGER SENSE OF SELF, IDENTITY

College students who major in a STEM field and have a dance minor indicate that they gauge their own self-efficacy as a sum of both their STEM and dance activities. They recognize the "duality of rigor" in STEM and dance and identify with both sides, despite implications of academic elitism and restrictive discipline identity from their peers (Payton, White, and Mullins 2017, 43).

"[Because of engagement with the arts] I found my true self. I became a better friend." (UM-AE: What role did the arts play in your development as a person, friend, colleague, and student during college?)

"You really find yourself through the arts. Traditional education will teach you and shape you, but through the arts you really get to find and define yourself." (UM-AE: In what ways do you think you can grow through the arts?)

PURPOSE AND MEANING

In response to the question "How did your involvement in the arts during college make you feel?" undergraduate study participants replied:

"It made me feel like I was growing in a whole new capacity that I didn't know was possible. Good, like I'm a part of something bigger than myself and bigger than this university." (UM-AE: How did your involvement in the arts during college make you feel?)

"Like I'm part of something important." (UM-AE: How did your involvement in the arts during college make you feel?)

"Like I had purpose." (UM-AE: How did your involvement in the arts during college make you feel?)

POSITIVE EXPERIENCE

"[The arts] especially made me feel expressive in a different way than my everyday life. It was a wonderful way to escape and have fun escaping." (UM-AE: How did your involvement in the arts during college make you feel?)

"I really enjoyed participating in the arts and it made the college feel a little smaller and more intimate." (UM-AE: How did your involvement in the arts during college make you feel?)

"I have loved my involvement in the arts at Michigan. It has made me feel valued. It has also been great socially and made me happy." (UM-AE: How did your involvement in the arts during college make you feel?)

FINDING BALANCE IN LIFE

"The arts have helped me continue a balanced lifestyle (by helping to relieve stress), and they have also helped me become a more 'cultured' person by viewing art from different cultures." (UM-AE: What role did the arts play in your development as a person, friend, colleague, and student during college?)

"It [the arts] helped me explore my own beliefs and contemplate new knowledge and perspectives I gained from other people and their experiences. Art helped me become a more open-minded, thoughtful, and well-rounded person." (UM-AE: What role did the arts play in your development as a person, friend, colleague, and student during college?)

"I think art provides a good balance to life. With the stress of my anticipated career choice, I will need time to do things for myself, for my own enjoyment. I think it will be just a wonderful way to reflect, to express, and to relax." (UM-AE: In what ways do you think you can grow through the arts?)

INCREASED CIVIC ENGAGEMENT

Data from the NEA's 2008 Survey of Public Participation in the Arts show that American adults who attend art museums or live art performances are far more likely than non-attendees to vote, volunteer, or take part in other community events. Arts participants also show a greater likelihood of involvement in sports, collaborative art-making, and taking their children to performances ("Art-Goers in Their Communities" 2009, 1-2).

The University of Wisconsin School of Business, which regularly incorporates the arts into its curriculum, engaged its first-year students in a hands-on art-making project designed to support the semester's focus on social justice themes. "Our printmaking project was designed to create an opportunity for students to discuss and think deeply about mass incarceration, police brutality, and problems with the criminal justice system. By working together in small groups to design and create their own posters, they add their voices to the on-going dialogue around these issues" (Richardson 2015, 5).

"[I've] become inspired to go out and change the world, change the nation and become a better person and American citizen." (UM-AE: In what ways do you think you can grow through the arts?)

INTRINSIC IMPACTS OF THE ARTS

An extensive study of audience responses to music, theatre, and dance performances at nineteen on-campus venues finds that, to varying degrees, audience members experience captivation as well as intellectual stimulation, emotional resonance, spiritual value, aesthetic growth, social bonding, and satisfaction (Brown and Novak 2007, 11-17). We can expect students to experience some of those intrinsic impacts when they encounter the arts.

NEGATIVE IMPACTS ON STUDENT EXPERIENCE

The negative impacts reported here are drawn from student talk about arts engagement in general. They usually refer to participation in student-run organizations such as dance clubs, choirs, and jazz ensembles, or to the use of art studios and "maker" spaces. However, we can readily imagine these same feelings of apprehension and intimidation arising from participation in an arts-integrated classroom or research project.

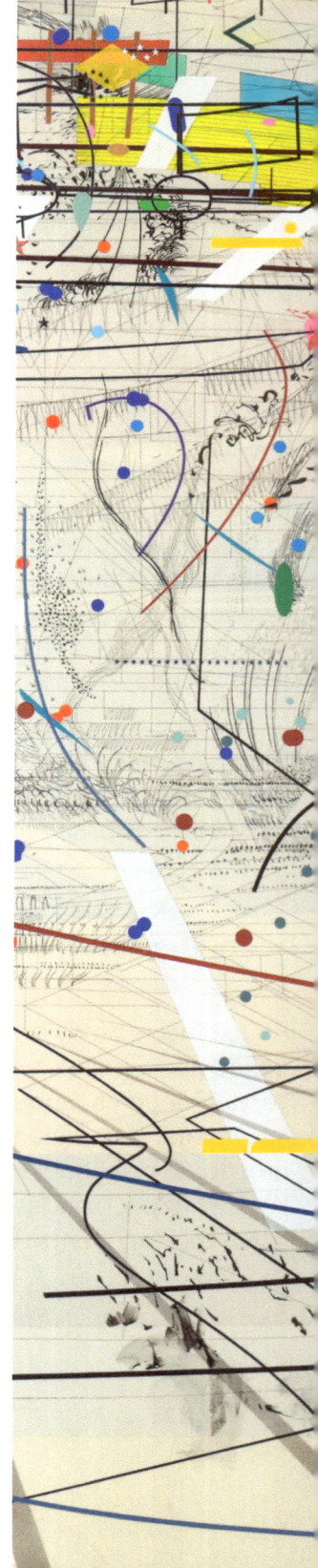

FEELINGS OF APPREHENSION AND ANXIETY

Undergraduates reported feeling anxiety at the prospect of participating in arts-related activities, because of a perceived inferiority in their skills or talents compared to their peers.

"I felt that I did not have the experience and talent of others participating in the arts." (UM-AE: What do you see as the barriers preventing you from being involved in the arts at the University of Michigan (if you experienced any)?)

"[There are] many other talented artists, which discourages people who aren't as naturally talented from participating because they aren't naturally 'artsy'…" (UM-AE: What do you see as the barriers preventing you from being involved in the arts at the University of Michigan (if you experienced any)?)

FEELINGS OF EXCLUSION AND INTIMIDATION

"I feel like the people that are involved are super passionate about the arts and sometimes I feel awkward going into their territory." (UM-AE: What do you see as the barriers preventing you from being involved in the arts at the University of Michigan (if you experienced any)?)

"I know a lot of people who want to join choirs/dance clubs/art clubs but feel intimidated that they are too 'novice' for them." (UM-AE: What do you see as the barriers preventing you from being involved in the arts at the University of Michigan (if you experienced any)?)

STUDENT LEARNING

Research demonstrates that although the arts do not increase IQ (as in the "Mozart effect"), they do support and enhance student learning in a range of ways. There is growing interest in how these effects are present in higher education, especially since the 2018 National Academies of Sciences, Engineering, and Medicine report that integration of the arts and humanities with STEMM (science, technology, engineering, mathematics, and medicine) courses is associated with positive learning outcomes in higher education (National Academies 2018, 170). All of the impacts on student learning cited here, except those in the category "Provide practical experience," which is derived from the SPARC interviews, are drawn from the literature on arts-integrative education.

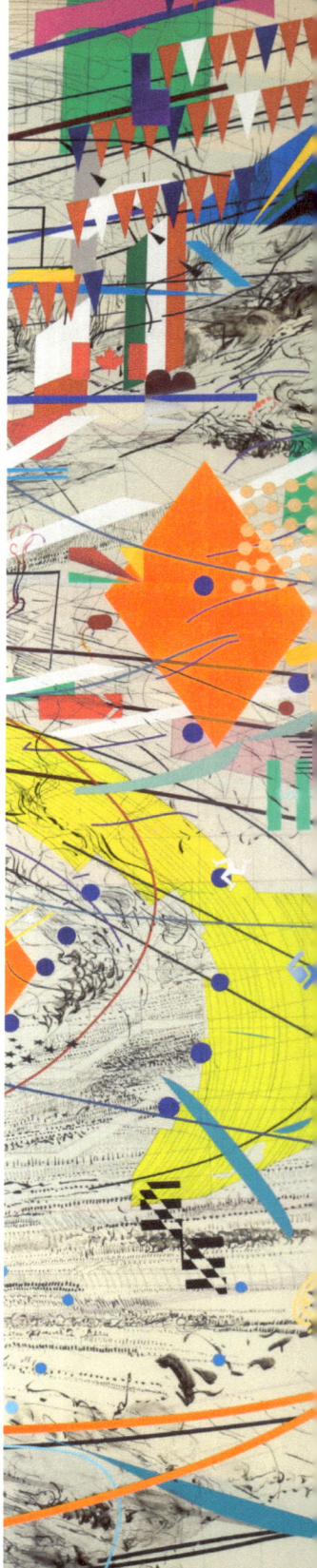

INCREASED RISK-TAKING

Several large meta-studies on arts-integration cite increased risk-taking as a positive learning outcome (Deasy 2002; Duma and Silverstein 2014, 6; Fiske 1999). While these are K-12 studies, the mechanism that they describe is salient for higher education: in the arts-integrated classroom, students manage risk through permission to fail, and then take risks that intensify the quality of their interactions and products (Fiske 1999, xi). Students take the time to identify and seek out helpful resources, "as opposed to stopping at ready solutions and refusing to take risks of being wrong" (Deasy 2002, 28).

SHOW KNOWLEDGE IN MULTIPLE WAYS

While the concept of different "learning styles" is difficult to define and assess, there is general agreement that students bring a range of interests, talents, and proclivities to the classroom. Teaching with respect to this diversity facilitates student growth and development (Sorcinelli 1991, 21). In an arts-integrated classroom, students have the opportunity to demonstrate knowledge in multiple ways (Duma and Silverstein 2014, 9), as they extend the presentation of their thinking beyond essays and slide presentations.

IMPROVED ATTITUDE/INCREASED MOTIVATION TO LEARN

Several K-12 studies note that students are more engaged and interested in learning in an arts-integrated classroom (Duma and Silverstein 2014, 10; Ruppert 2006, 14). At the college level, a six-year qualitative study of an arts-integration initiative reports that students' creativity and self-confidence were bolstered, which in turn led to a changed attitude toward studies (Dahlman 2007, 276). This affective impact has implications for higher education, where burn-out and stress are common factors in student life. Undergraduates at the University of Michigan report that through their arts engagement, they feel less stressed, more refreshed, and better able to engage with new ideas and thinking (AE-UM: How did your involvement in the arts during college make you feel?)

MAKE CONNECTIONS AMONG DOMAINS AND IDEAS

Arts integration, as distinct from arts education, holds the promise of the arts interacting with and influencing other areas of inquiry. Indeed, one meta-study of K-12 arts integration reports, "Students engage in the creative process to explore mutually reinforcing connections between an art form and another curriculum area to meet evolving objectives in both" (Duma and Silverstein 2014, 6). Another K-12 study suggests that "…learning in the arts and in other subjects each contribute in their distinctive ways to a constellation of higher order cognitive capacities and dispositions—or ways of thinking—by activating them within broad and flexible pedagogical contexts" (Burton, Horowitz, and Abeles 2000, 253). These relationships have implications for the idea of transference, especially for college students who, as they did in one study, demonstrate the ability to fluidly connect ideas across courses (Barber 2012, 608).

IMPROVED LONG-TERM RETENTION OF CONTENT

Several studies indicate that arts integration improves students' long-term retention of content (Hardiman, Rinne, and Yarmolinskaya 2014, for example). This improvement can be at least partly attributed to the experiential aspects of the arts: "Retention of course concepts was also a benefit of the hands on approach to learning in the ArtScience program. In line with the experiential learning framework, participants noticed that the experience, or the 'making,' process helped the course content 'stick'" (Ghanbari 2014, 95)

VARIOUS POSITIVE COGNITIVE EFFECTS

A host of studies demonstrate that learning in the arts positively impacts various aspects of cognition that affect learning. These include cognitive control (D'Esposito 2008, 72), reasoning (Dunbar 2008, 82), generating novel and creative concepts (Dunbar 2008, 82), multiple or alternative vantage points (Burton, Horowitz, and Abeles 2000, 246), construction and organization of meaning (Burton, Horowitz, and Abeles 2000, 246), focused perception (Burton, Horowitz, and Abeles 2000, 246), critical thinking and problem-solving skills (Duma and Silverstein 2014, 9), increased access to procedural and schematic knowledge (Hardiman and Rich 2009), abstract thought (Ruppert 2006, 13), and more (for example, Catterall 2005; Moga et al 2000).

PROVIDE PRACTICAL EXPERIENCE

"The MCAT, the entrance exam for medical school, is shifting in 2015 to accomplish much stronger emphasis for testing prospective medical students on social, cultural, and psychological content. They've come around to recognizing that health care practitioners really need to have some background in the social and behavioral sciences. For these students, they're first year students, and they get a heavy dose of me right away. I have that opportunity to influence their thinking for a full year. Are they going to do well on the MCAT because of that? I would hope." (Q25-2911-1531)

"A local blues musician called me…She was getting ready to go on an international tour, and she said, 'I need a student [from your program] to come in and help me with the marketing, with event planning,' kind of the business component of it, plus sound production as well. We sent it out to our students. We get them connected like that." (Q25-2406-4027)

"They [our alums] begin to get promoted faster in the workplace and students have even, not students, some of the new employees have turned to our alums and said 'Why aren't you sweating through this exercise? Why aren't you terrified?' He [our alum] said 'Oh, I've done this so many times before,' or 'I've worked with these types of people and they're wonderful.' And so it's been exciting." (Q25-2901-1318)

NEGATIVE IMPACTS ON STUDENT LEARNING

It is unusual to find negative impacts of arts integration, either in our interview data or in the literature. Nonetheless, we understand that negative experiences surely exist, and need attention if we are to gain a full and useful picture of the landscape of arts integration in the university.

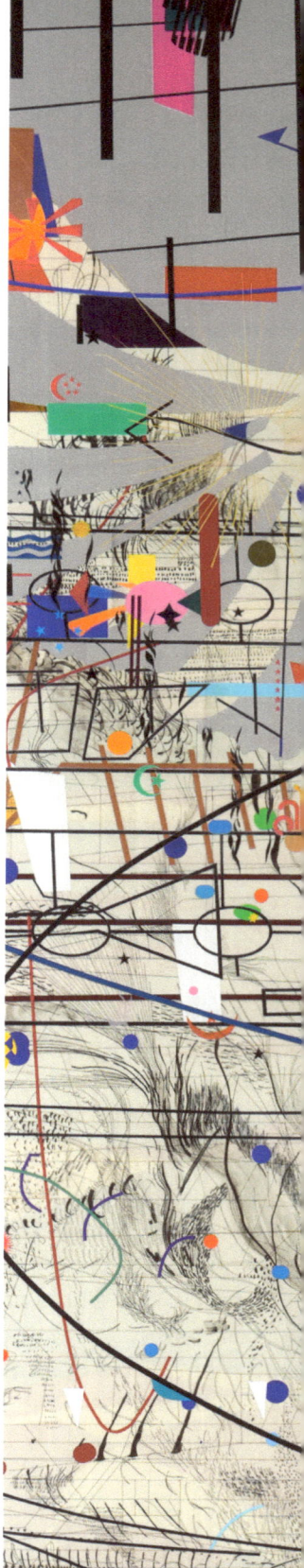

CONFLICT BETWEEN ARTS AND ACADEMICS

In a study of one high school that adopted an arts-integrated curriculum, there were—in addition to positive impacts—instances of conflict between the arts and academics, when academic achievement was considered secondary to arts experiences and grades did not improve (Dorfman 2008, 55). A similar conflict is possible in the college classroom, if, for instance, the arts became students' main focus, usurping attention from non-arts content.

STUDENT FUTURES

The effect that an arts-integrative course or program has on students' futures, particularly on their employment after graduation, is mentioned frequently in the SPARC interviews, perhaps because it is such a tangible impact. Interviewees boast that their graduates get good-paying jobs working as artists, designers, entrepreneurs, academics, and in many other fields, and take on leadership roles. This category also encompasses continued higher education as well as attitudes that students carry with them beyond the classroom. Students who continue working in an arts-integrative or interdisciplinary vein post-graduation, or who cross disciplinary boundaries merit special mention.

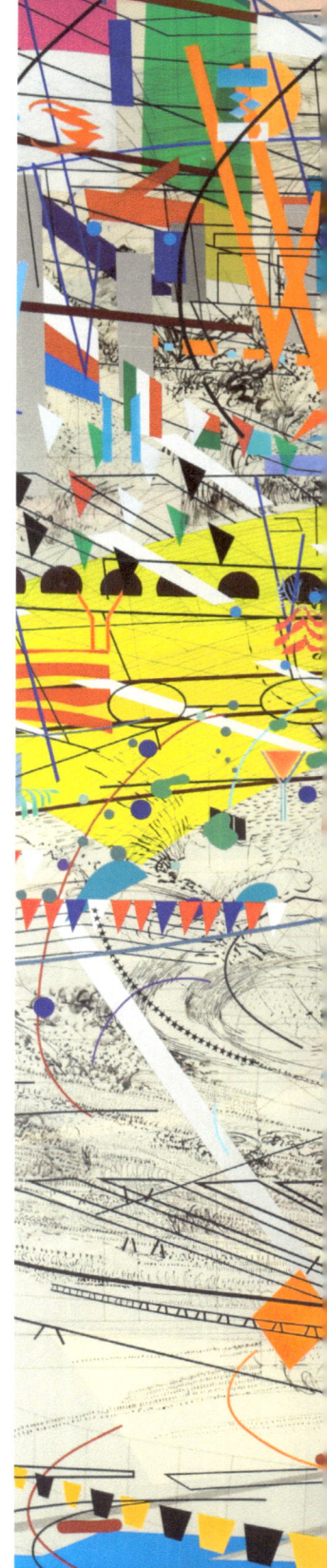

GRADUATE SCHOOL

"It was not obvious that any of them [students in the class] was going to do that in the beginning, but a couple of them took a master's and a couple are going for their PhD." (Q25-2909-1495)

"From our last class, someone got in the forensics graduate program at [a prestigious university], for photography. She said it was these kinds of classes that made her think about other applications." (Q25-2919-1691)

JOBS AFTER GRADUATION

"So we've had a number of students form artistic companies together that ten years later are still in New York City, actively producing seasons of new work." (Q25-2002-4952)

Art students find success in non-traditional fields such as museum display fabrication and parade floats. (Q25-3614-8212)

"I would point to the graduates of the program who have gone off to do some pretty substantial work...at Facebook and IDEO and all sorts of places." (Q25-3614-8212)

"One of our graduates now runs one of the finest eco-friendly building material supply houses in the country, and he has a huge clientele." (Q25-3614-8212)

PROFESSIONAL SUCCESS THAT HINGES ON ARTS-INTEGRATIVE OR INTERDISCIPLINARY EXPERIENCE

Art majors go on to medicine, business, law, and finance: "Many students come back to me and they told me, well, we got to the [med school] interview. The interview was not at all about biology or this stuff, it was all about Leonardo da Vinci and his anatomical drawings. Things that they had worked with me. There is that part in which visual and historical background actually puts them on an edge." (Q25-1302-7083)

"We have dance majors who are actually running these kinds of companies that involve this engineering and marketing process." (Q25-2404-3984)

An alumna works at the intersection of museum display, science, and photography: "She's so interdisciplinary that nobody from any of the disciplines she works in knows who she is!" (Q25-3614-8212)

ALTERED ATTITUDES AND PRIORITIES

Students think more intentionally about their possible role in the community after graduation: "I think a lot of them come in thinking, 'Well, I'm going to be the high school band director,' and that's great, but what about the nursing home around the corner or the center downtown for the children with special needs, or what are some other things in the community?" (Q25-2914-1579)

"I really like to see, down the line, final outcomes, in terms of was that course instrumental in some way in that a student made a decision to follow an interdisciplinary path themselves? Did it end up in their research later on, or did it even preferably end up as a potential career?... We do find, sometimes, that if a course is innovative enough, that it will change somebody's mind about the direction that they were heading with their own career." (Q25-1203-6391)

REFERENCES

"The Arts and Human Development: Framing a National Research Agenda for the Arts, Lifelong Learning, and Individual Well-Being." 2011. Washington, D.C.: National Endowment for the Arts in partership with the U.S. Department of Health and Human Services. https://www.arts.gov/publications/arts-and-human-development-framing-national-research-agenda-forthe-arts-lifelong.

"Art-Goers in Their Communities: Patterns of Civic and Social Engagement." 2009. NEA Research Note 98. Washington, D.C.: National Endowment for the Arts. https://www.arts.gov/publications/art-goers-their-communities-patterns-civic-and-social-engagement.

Barber, James P. 2012. "Integration of Learning: A Grounded Theory Analysis of College Students' Learning." *American Educational Research Journal* 49 (3): 590–617.

Brown, Alan S. and Jennifer L. Novak. 2007. *Assessing the Intrinsic Impacts of a Live Performance*. San Francisco, CA: WolfBrown.

Burton, Judith M., Robert Horowitz, and Hal Abeles. 2000. "Learning in and Through the Arts: The Question of Transfer." *Studies in Art Education* 41 (3): 228–57. https://doi.org/10.2307/1320379.

Catterall, James S. 2005. "Conversation and Silence: Transfer of Learning through the Arts." *Journal for Learning through the Arts* 1 (1). https://eric.ed.gov/?id=EJ1095279.

Dahlman, Ylva. 2007. "Towards a Theory That Links Experience in the Arts with the Acquisition of Knowledge." *International Journal of Art & Design Education* 26 (3): 274–84. https://doi.org/10.1111/j.1476-8070.2007.00538.x.

Deasy, R.J. 2002. *Critical Links Learning in the Arts and Student Academic and Social Development*. Washington: Arts Education Partnership.

D'Esposito, Mark. 2008. "Developing and Implementing Neuroimaging Tools to Determine if Training in the Arts Impacts the Brain." In *Learning, Arts, and the Brain: The Dana Consortium Report on Arts and Cognition*, edited by Carolyn H. Asbury and Barbara Rich, 71-80. New York: Dana Press. http://dana.org/Publications/PublicationDetails.aspx?id=44422.

Dorfman, Dorinne. 2008. "Arts Integration as a Catalyst for High School Renewal." *Studies in Art Education* 50 (1): 51–66. https://doi.org/10.2307/25475886.

Duma, Amy, and Lynne Silverstein. 2014. "A View into a Decade of Arts Integration." *Journal for Learning through the Arts* 10 (1). https://escholarship.org/uc/item/3pt13398#page-4.

Dunbar, Kevin Niall. 2008. "Arts Education, the Brain, and Language." In *Learning, Arts, and the Brain: The Dana Consortium Report on Arts and Cognition*, edited by Carolyn H. Asbury and Barbara Rich, 81-92. New York: Dana Press. http://dana.org/Publications/PublicationDetails.aspx?id=44422.

REFERENCES

Fiske, Edward B, ed. 1999. *Champions of Change: The Impact of the Arts on Learning*. Washington, D.C.: Arts Education Partnership.

Ghanbari, Sheena. 2014. "Integration of the Arts in STEM: A Collective Case Study of Two Interdisciplinary University Programs." Ed.D., United States -- California: University of California, San Diego. http://search.proquest.com/docview/1557734683/abstract/D3FE330C4D16431FPQ/1.

Hardiman, Mariale M. and Barbara Rich. 2009. "Neuroeducation: Learning, Arts, and the Brain." In *Findings and Challenges for Educators and Researchers from the 2009 Johns Hopkins University Summit*. New York: Dana Press. http://bibpurl.oclc.org/web/39725 http://www.dana.org/WorkArea/showcontent.aspx?id=23972.

Hardiman, Mariale, Luke Rinne, and Julia Yarmolinskaya. 2014. "The Effects of Arts Integration on Long-Term Retention of Academic Content." *Mind, Brain, and Education* 8 (September). https://doi.org/10.1111/mbe.12053.

Moga, Erik, Kristin Burger, Lois Hetland, and Ellen Winner. 2000. "Does Studying the Arts Engender Creative Thinking? Evidence for Near but Not Far Transfer." *Journal of Aesthetic Education* 34 (3/4): 91-104. https://doi.org/10.2307/3333639.

National Academies of Sciences, Engineering. 2018. *The Integration of the Humanities and Arts with Sciences, Engineering, and Medicine in Higher Education: Branches from the Same Tree*. Washington, D.C.: The National Academies Press. https://doi.org/10.17226/24988.

Payton, Fay Cobb, Ashley White, and Tara Mullins. 2017. "STEM Majors, Art Thinkers (STEM + Arts) – Issues of Duality, Rigor and Inclusion." *Journal of STEM Education : Innovations and Research* 18 (3): 39–47.

Richardson, Angela. 2015. "The Just Mercy Project - Fall 2015." Wisconsin School of Business. https://bus.wisc.edu/-/media/bus/knowledge-centers/bolz/just-mercy-project_summary.pdf?la=en.

Ruppert, Sandra. 2006. *Critical Evidence: How the ARTS Benefit Student Achievement*. Washington, D.C.: National Assembly of State Arts Agencies in collaboration with the Arts Education Partnership.

Sorcinelli, Mary Deane. 1991. "Research Findings on the Seven Principles." *New Directions for Teaching and Learning* 1991 (47): 13–25. https://doi.org/10.1002/tl.37219914704.

SOURCE CITATIONS

In-text citations refer readers to the reference list above. Note that much of the research on arts integration is done with the K-12 population. We refer to that literature only when we deem that the impacts discussed are applicable to college-age students as well.

Examples from the SPARC interview data have an in-text citation indicating the unique identifier number of the quotation, but do not appear in the reference list. Each identifier has a prefix that begins with the letter "Q" and a number, indicating the question to which the speaker was responding.

Readers interested in the context for these examples can visit Supporting practice in the arts, research, and curricula (SPARC), 2012-2015, in the National Archive of Data on Arts & Culture. https://doi.org/10.3886/ICPSR36823.v1

Examples from the U-M Arts Engagement study also have an in-text citation but do not appear in the reference list. These examples are identified only by the question to which the speaker was responding. As of summer, 2019, the results of the UM Arts Engagement study are under review for publication. Study authors are Gabriel Harp, Debra Mexicotte, Jack Bowman, and Mengden Yuan.

Image Credits:

Stadia II, 2004. © Julie Mehretu.

By permission: Julie Mehretu studio; Marian Goodman Gallery; and Carnegie Museum of Art, Pittsburgh.

FOLLOW-UP: QUESTIONS FOR BUILDING UNDERSTANDING

Identify from your institution three examples of the types of impact in this report.

Identify three examples of these types of impact from somewhere else.

What experiences, methods, and/or practices help impacts related to students emerge?

How do impacts manifest in different ways for different people?

What teaching and learning activities would be relevant for deepening particular impacts in this report?

What kinds of institutional barriers might get in the way of these impacts?

What kinds of incentives or programs could broaden the impacts of arts-integrative teaching, engagement, and/or research?

What counts as evidence for the impacts in this report? What challenges might those who do arts-integrative work face when seeking evidence or justification for these impacts?

IMPACTS RESEARCH PROCESS: STAGE 1

The insights in this report are based on responses to the following questions in a2ru's SPARC (Supporting Practice in the Arts, Research and Curricula, funded by the Andrew W. Mellon Foundation) interview cycle, which took place 2012-2015.

What impact did you hope to see? What impact did you actually see and how did you measure it? (Question 25)

How have these programs affected your teaching and research? What about your colleagues' teaching and research? [and variations of this wording] (Question 26)

The interviews were recorded and transcribed, and a2ru staff parsed and cleaned the transcripts. There were 212 individual responses in which people talked about a range of experiences—from awards and recognition for innovative research, to strengthened student communities, to sensory gardens for the blind.

From these responses, we tagged every instance in which an interviewee identified an impact of their arts-integrative work and, in the service of distilling this large data set (273 examples), applied a bottom-up coding process. We grouped similar types of impact together, eventually developing a taxonomy of major categories of impact. Since most interviewees did not distinguish between intended and actual impacts, this data set becomes a catalogue of "possible impacts."

We found that the major categories we had identified differ in type. Some center on the object of impact, such as "impact on the community" or "impact on research," and some seem more action-centered, such as "generates involvement and enthusiasm" or "promotes community and collaboration." To make sense of the data, we constructed roles for and relationships among the categories, generating an organizational structure that is fully represented in the comprehensive report on impacts and in the graphic map of impacts, and partially represented in shorter, targeted reports such as this one. Our sense-making, as articulated in this structure, is, of course, inductive and subjective; there are alternative ways of telling the story of this data.

SPARC DATA SAMPLE INFORMATION

The 155 respondents to these two questions were primarily faculty (79%), but also included those in leadership roles at the Director, Dean, and Provost levels (17%), as well as other staff such as curators and librarians. Notably, half of those who identify as Professor also serve in leadership roles. Eighty-eight per cent of those interviewed worked at Research 1 or Research 2 universities, with the remainder at colleges and universities with larger Master's programs, arts-focused four-year schools, and universities with very high research activity.

SPARC interviewees represented disciplinary clusters as follows:

Music, Theatre, and Dance	27%
Fine, Contemporary, and Media Arts	21%
Engineering, Design, Information, and Architecture	18%
Humanities	15%
Natural Sciences and Medicine	10%
Social Sciences, Education, Business, and Law	8%

IMPACTS RESEARCH PROCESS: STAGE 2

In 2018, we expanded our impacts taxonomy with a literature review and an additional data set — the four-year longitudinal Arts Engagement study of ~4000 undergraduates at the University of Michigan.

As a result of this supplementary research, we revised some aspects of our structure, including the identity of high-level categories and the relationships among those categories. In addition, we added new sub-categories and examples of impact to our taxonomy. However, readers should note the difference in process between the SPARC research and this supplemental research, and how it manifests in these reports. The original, interview-based research followed a bottom-up process, in which examples—quotations drawn from interviews—formed the foundation. We gathered together examples that were similar in type, and these eventually formed sub-categories, which coalesced into categories. By contrast, with the literature review, we sometimes found categories of impact suggested by research that didn't have accompanying examples (a more top-down approach). Because of this, the reader will notice that some categories of impact are rich with real-life examples while others have theorizing but no examples. Both types serve the goal of the taxonomy—to describe the rich landscape of impacts—even though the narrative representation varies.

ARTS ENGAGEMENT DATA SAMPLE INFORMATION
Interviewees were University of Michigan undergraduate students who responded to questions about the arts in their college experience. This report draws on the following questions from that survey:

In what ways do you think you can grow through the arts? n=971

How did your involvement in the arts during college make you feel? n=1207

What role did the arts play in your development as a person, friend, colleague, and student during college? n=840

What do you see as the barriers preventing you from being involved in the arts at the University of Michigan (if you experienced any)?) n=3857

FUTURE QUESTIONS AND DIRECTIONS FOR RESEARCH

How can we mobilize existing knowledge to broaden our understanding of the impacts of arts integration? What other research overlaps this investigation, allowing the appropriation of relevant findings? What useful perspectives can sociology, psychology, game theory, business, history, and countless other domains lend to this research?

How can we delve deeper into the impacts in this report? How could we establish a causal relationship (not just a correlative one) between arts-integration and a single impact such as "thinking differently"? Could a small-scale longitudinal study go even further, providing not only evidence of causality but even an explanation of how that impact is effected? What other means exist for learning more about the impacts we have discovered?

How can we develop an effective measurement of impact? What tools, methodology, and evidence are appropriate for demonstrating impact? How might new information about the scope or type of impact, obtained through measurement, feed back into the work we do?

How is the picture presented in this report incomplete? What impacts are missing, and where are the gaps? What impacts of arts integration and interdisciplinarity need to be surfaced and addressed?

How else might the impacts data be structured? We have assigned roles and relationships to individual pieces of data and built an organizational structure around them. What are alternative ways to tell the story of the data?

www.ingramcontent.com/pod-product-compliance
Lightning Source LLC
Chambersburg PA
CBHW041210180526
45172CB00006B/1225